How to Draw
Kawaii
Animals

In Simple Steps

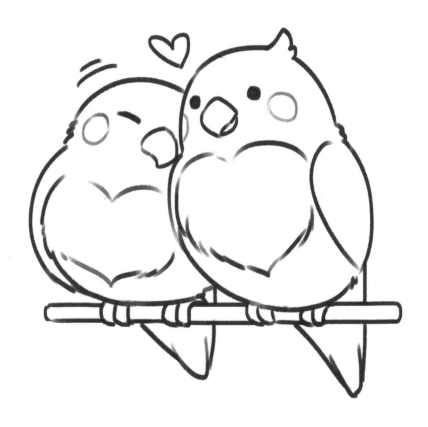

First published in Great Britain 2020

Search Press Limited
Wellwood, North Farm Road,
Tunbridge Wells, Kent TN2 3DR

Reprinted 2021 (twice), 2022, (twice), 2023

Text copyright © Search Press LTD 2020

Design and illustrations copyright © Search Press Ltd. 2020

ISBN: 978-1-78221-918-7

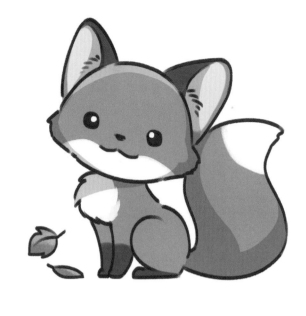

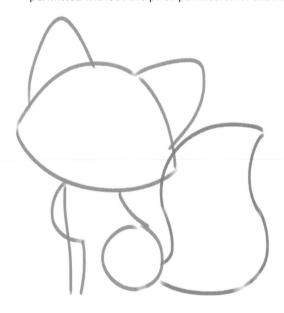

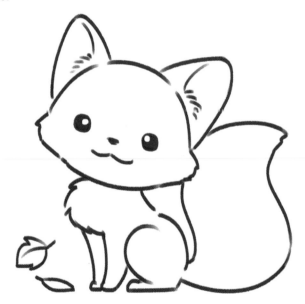

Illustrations

Dog 5	Bear 19
Cat 6	Tiger 20
Hamster 7	Alpaca 21
Rabbit 8	Panda 22
Chameleon 9	Racoon 23
Parrot 10	Gorilla 24
Mouse 11	Meerkat 25
Fox 12	Koala 26
Horse 13	Hippo 27
Sheep 14	Frog 28
Cow 15	Shark 29
Chicken 16	Beaver 30
Elephant 17	Penguin 31
Sloth 18	Turtle 32

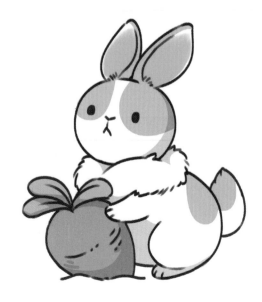

How to Draw
Kawaii Animals

In Simple Steps
Yishan Li

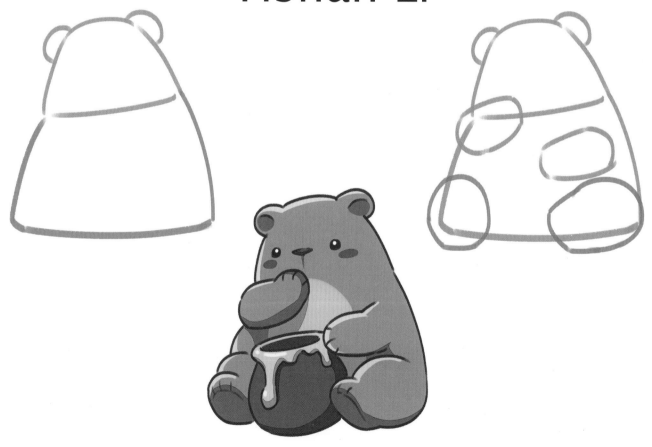

Search Press

Introduction

If you have watched anime or read Manga books before, you probably know the word 'kawaii'. Kawaii in Japanese means cute, adorable or loveable, and it is a massive part of Japanese culture. And of course, animals are cute anyway! Now you can make them look even cuter by drawing them the kawaii way. So, if you love cute animals, with a little help from this simple-to-follow book, you can learn to draw them yourself.

In this book there are 28 finished images of kawaii animals and each of them has eight steps to guide you through the whole drawing process. They all start with very simple shapes, then gradually build up more shapes and details. I have used different colours to indicate the new strokes added at each stage. The first shape is always blue, then new shapes added will be pink. After that, black lines are used to draw the actual image, then the final image is fully coloured to show you the complete picture.

When you practise, all you need is paper, a pencil and an eraser. I prefer normal copying paper to special art paper because it's cheaper and easy to draw on. You can choose any soft graphite pencil, preferably 2B. The eraser can just be the one you normally use at home or school.

When drawing the initial shapes, start with very light strokes, then when you are adding more details, you can use slightly more solid lines. This way you can see your final image clearly rather than losing it among all the messy lines.

Once you are more confident with your black and white pencil drawings, you can add ink and colours. You need an ink pen and colouring materials. The ink pen can be any black waterproof gel pen. Try it first on a spare piece of paper to make sure it doesn't smudge.

When you have inked in the drawing, you can clear away all the pencil lines with the eraser. For colouring pens, I prefer water-based dye ink pens, but if you would rather use something easy to find at home, you can also use watercolour or ordinary coloured pencils.

The most important thing I hope you will learn from this book is to be creative. You can draw any animal in the kawaii style if you add just a bit of creativity!

Happy Drawing!

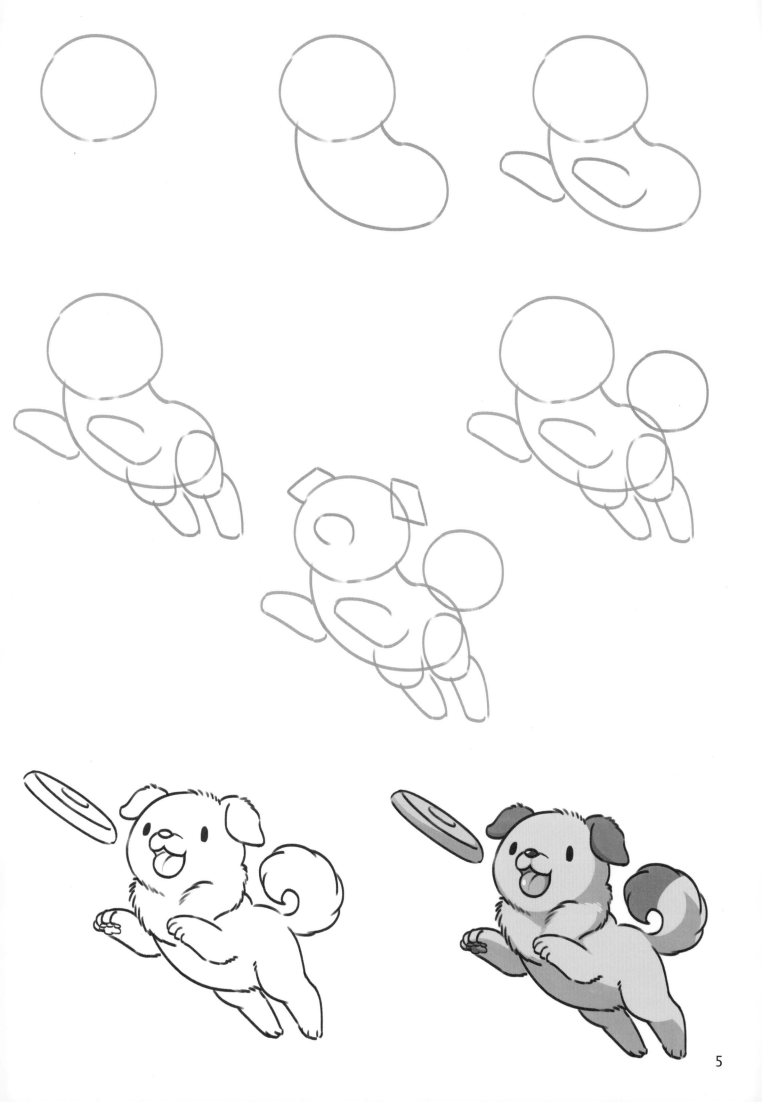

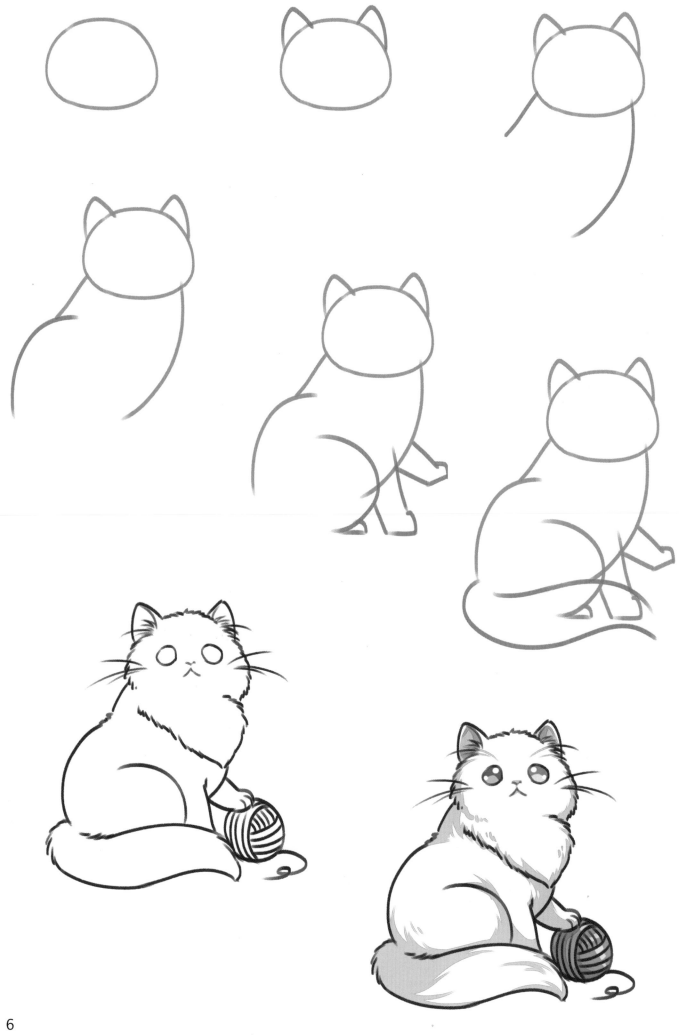

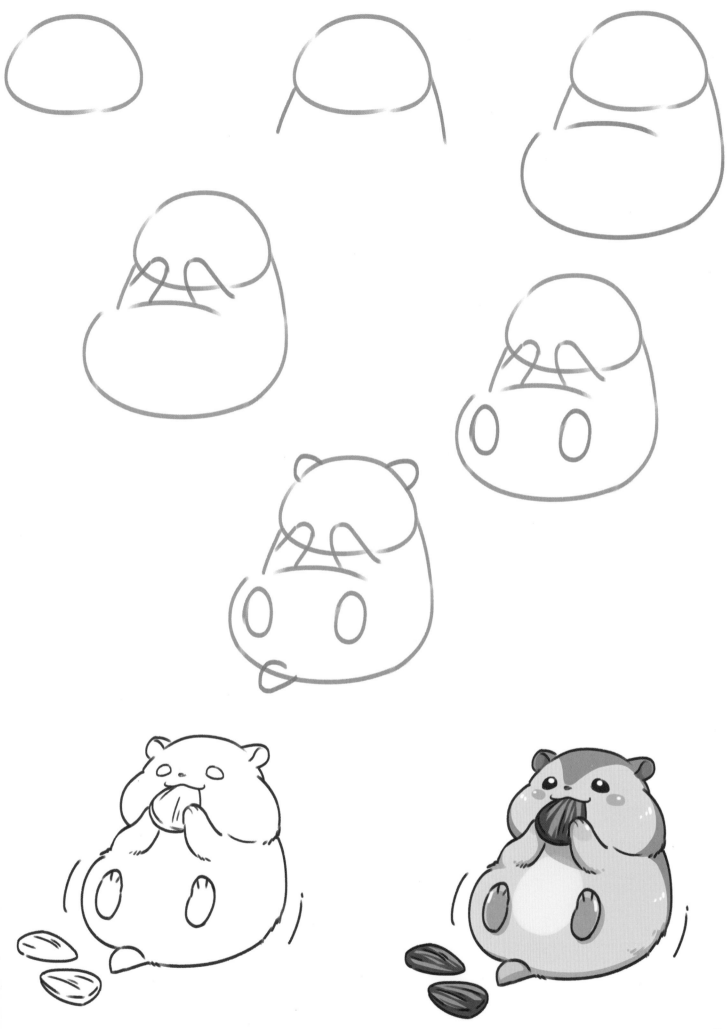

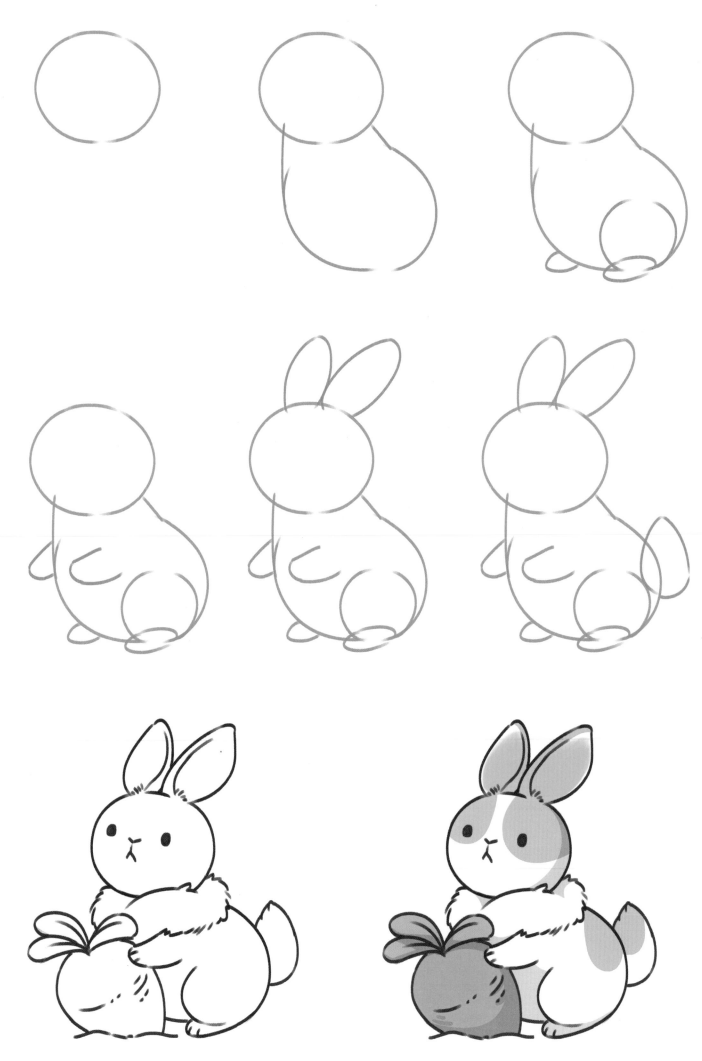

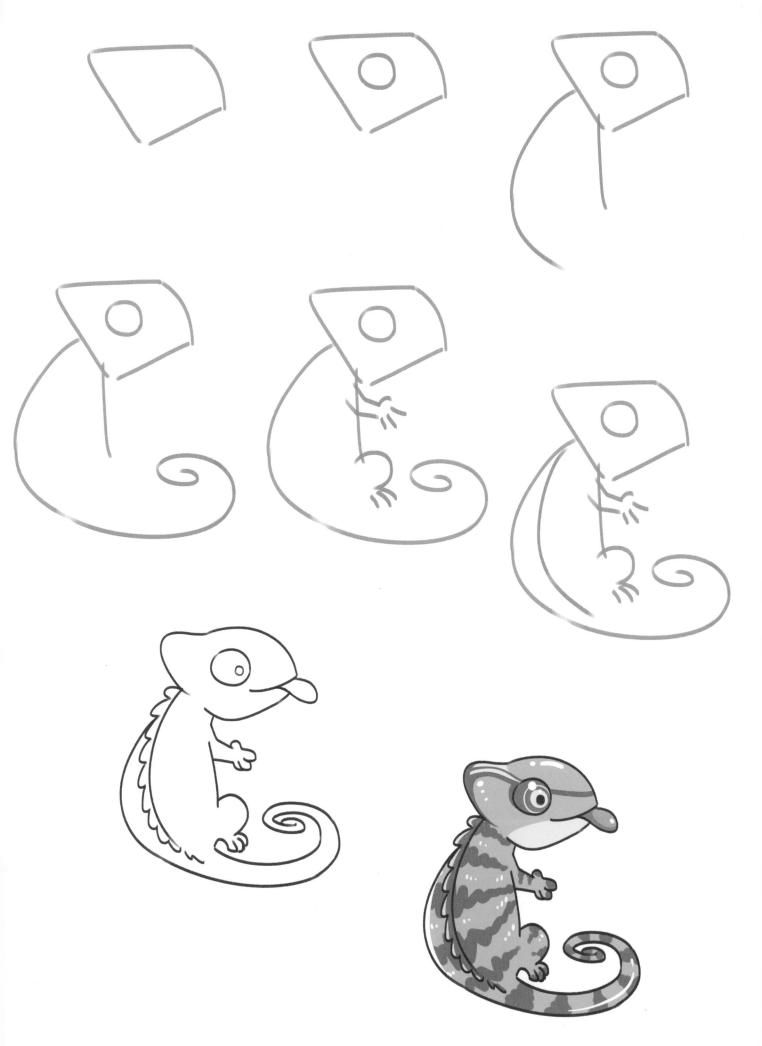

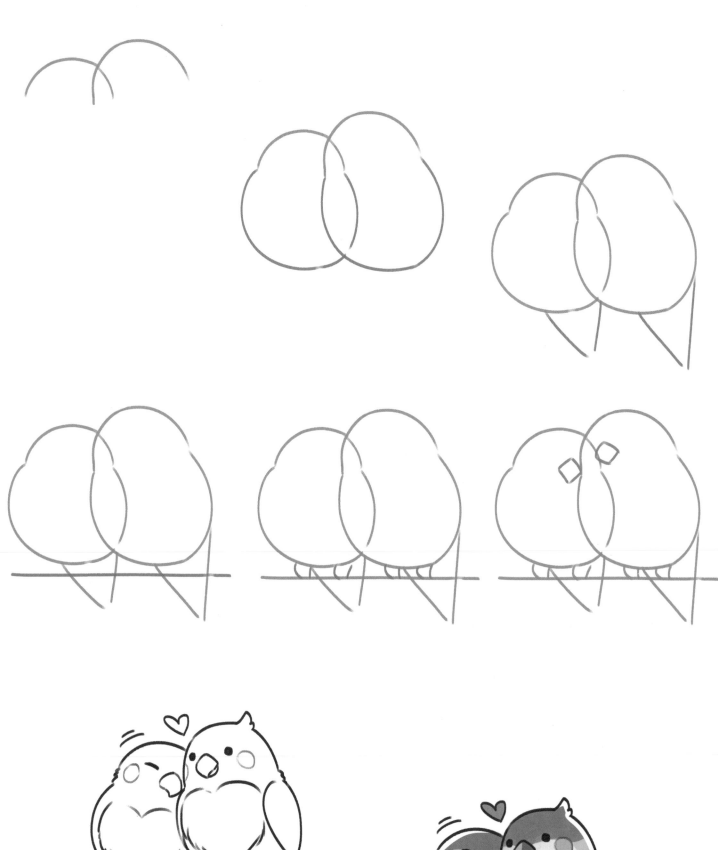

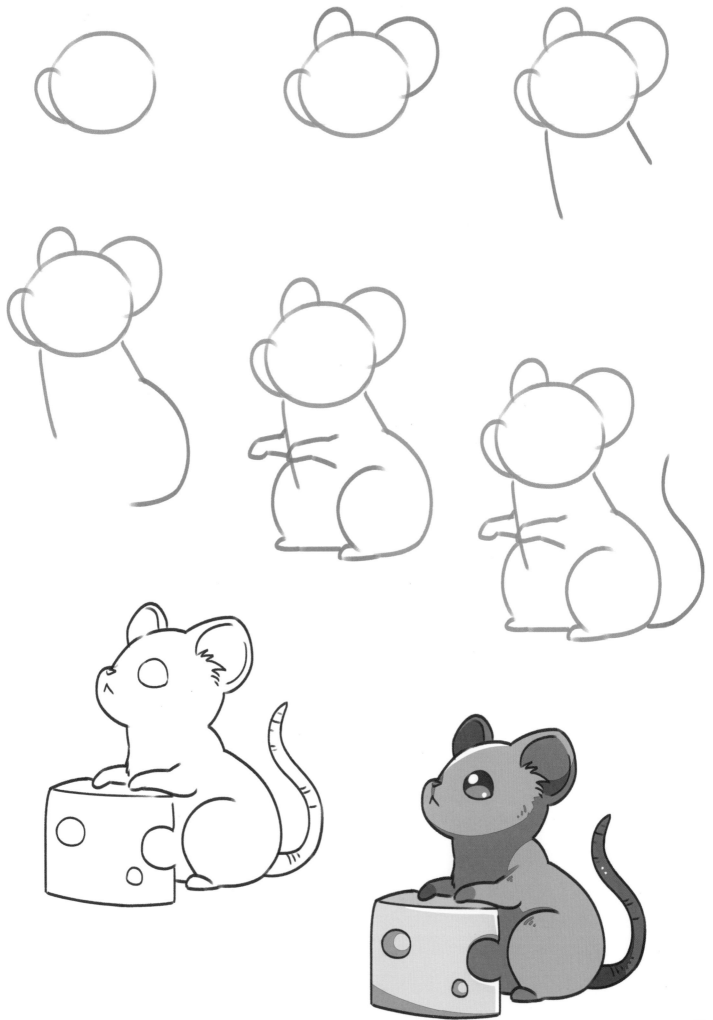

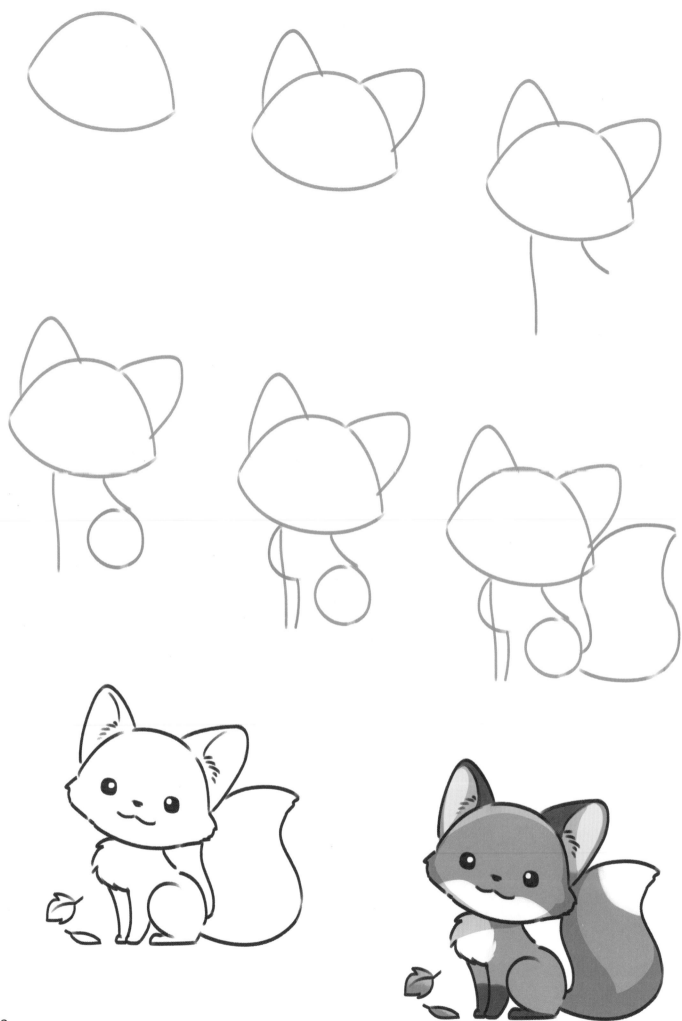

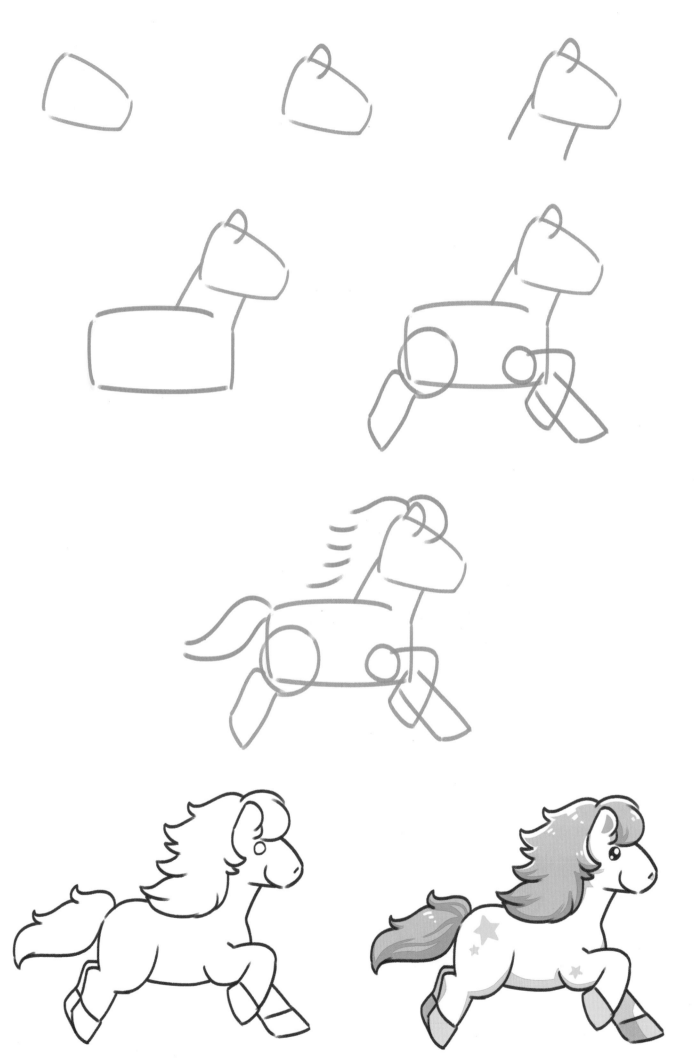

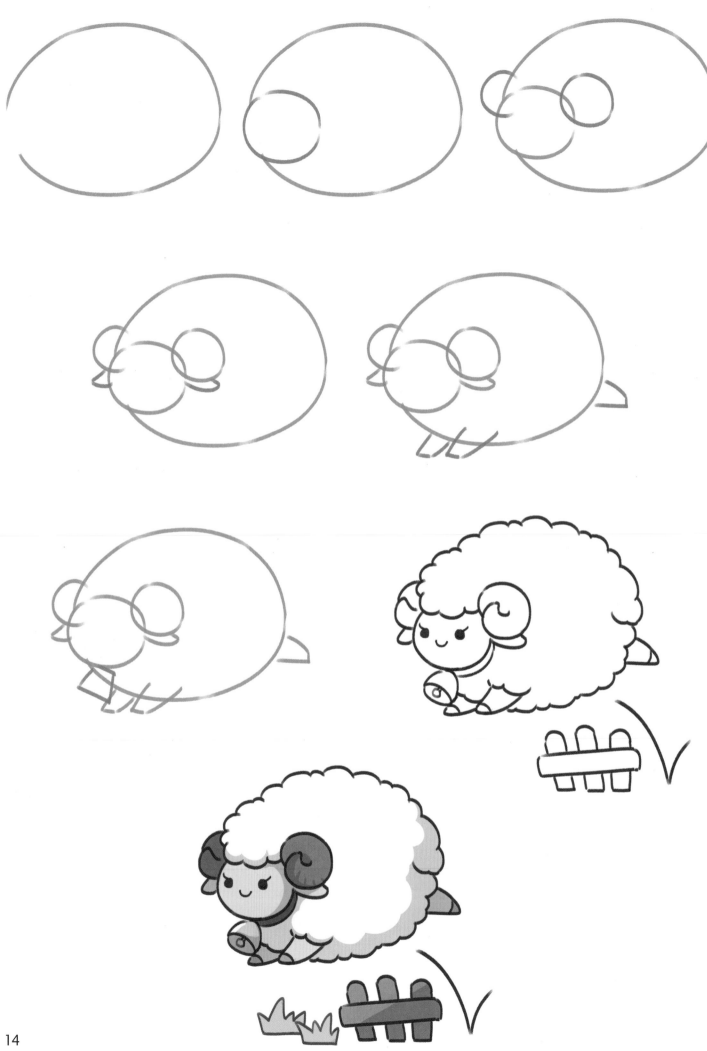

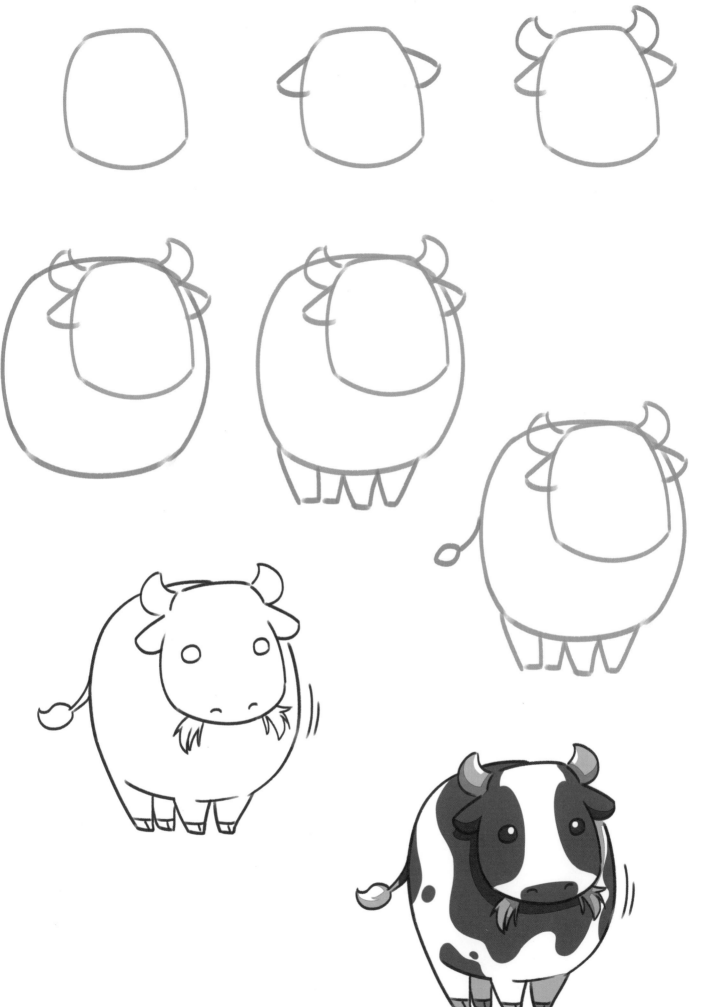

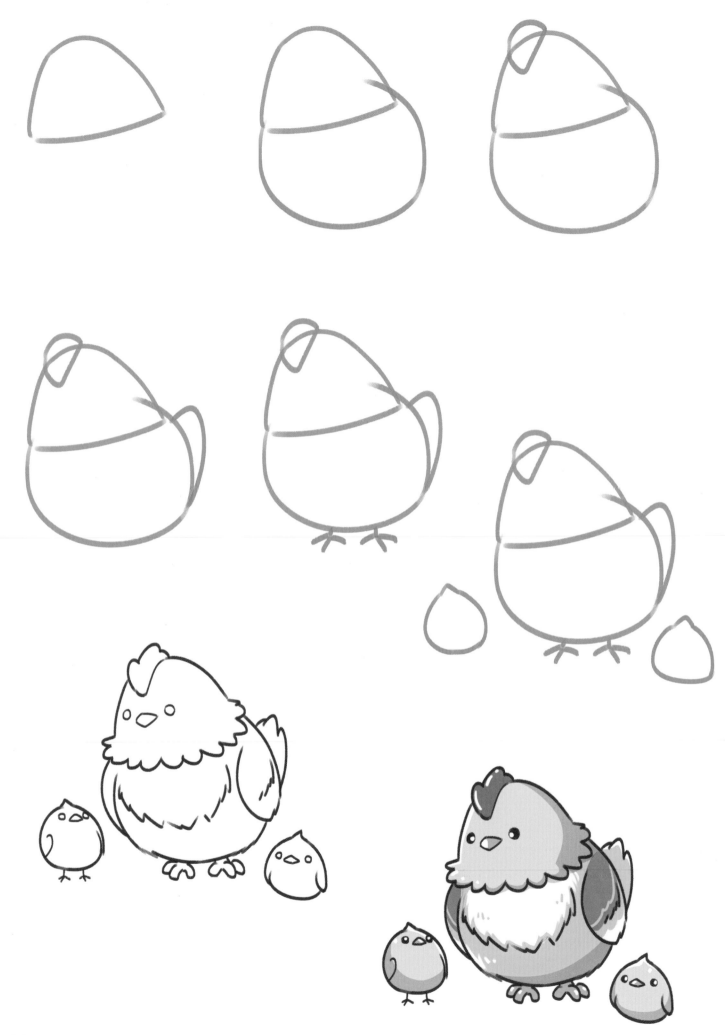

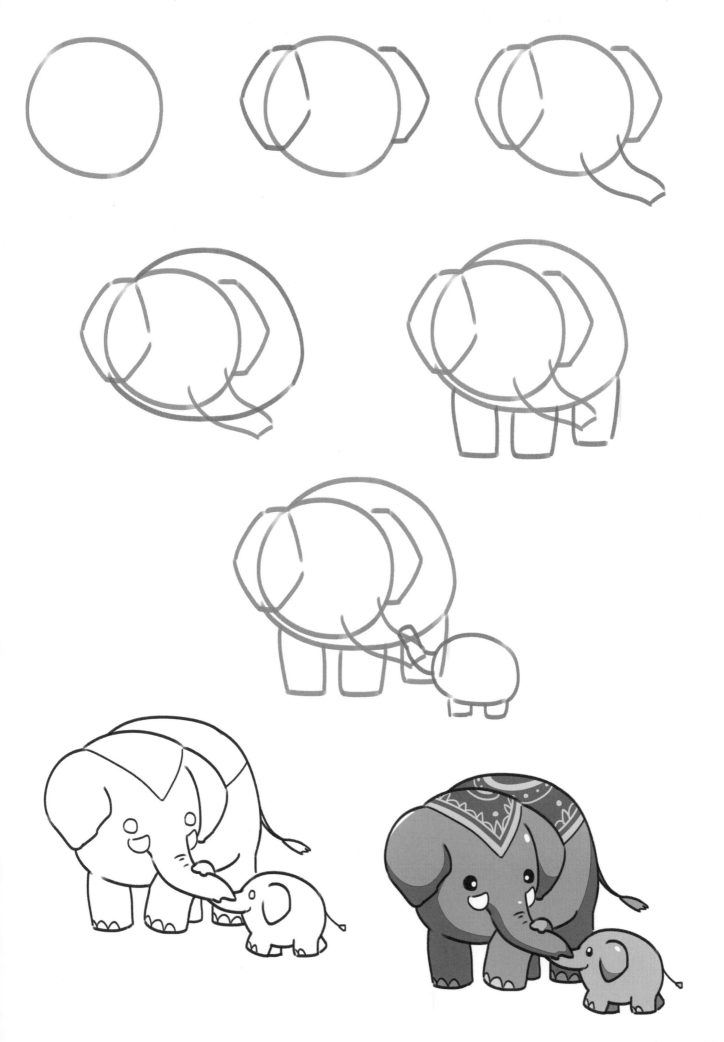

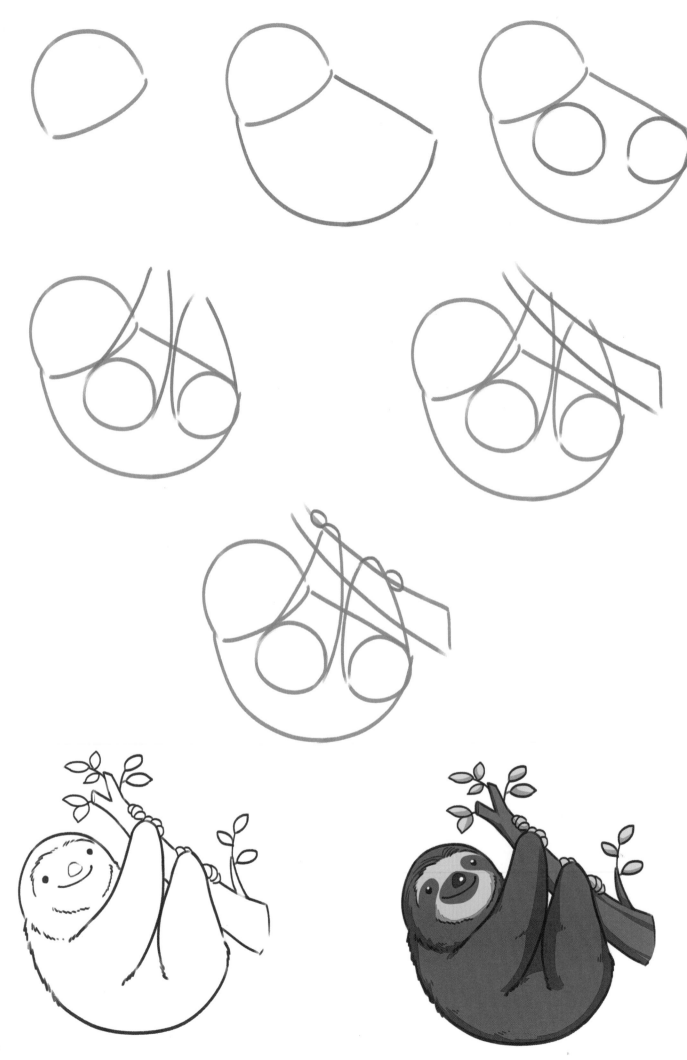

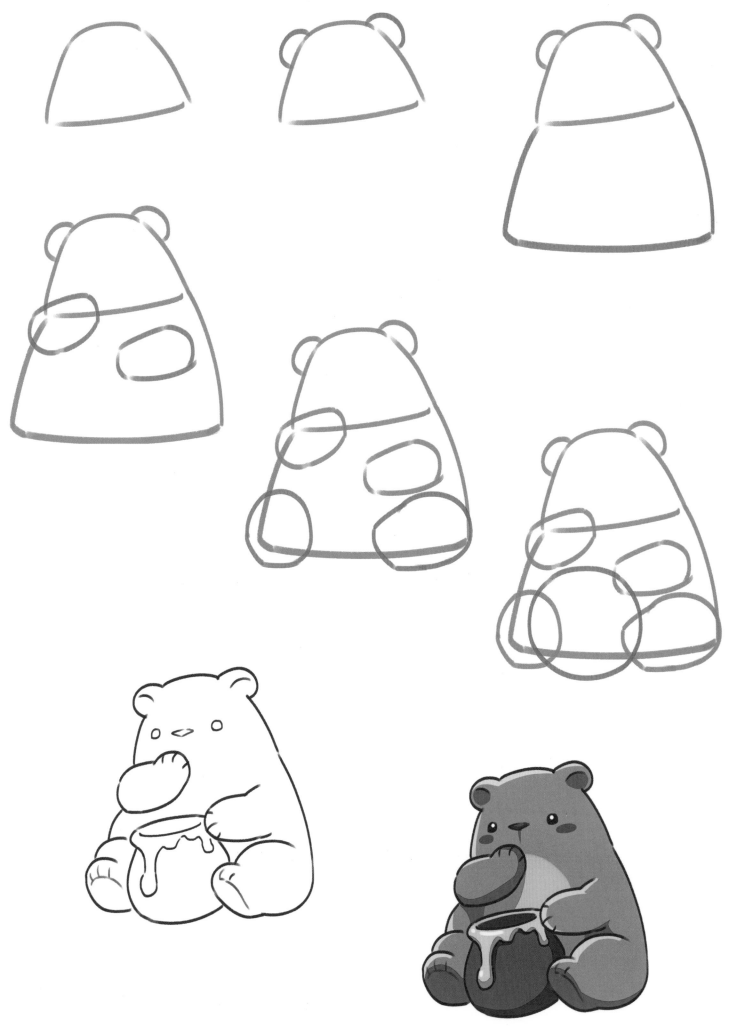

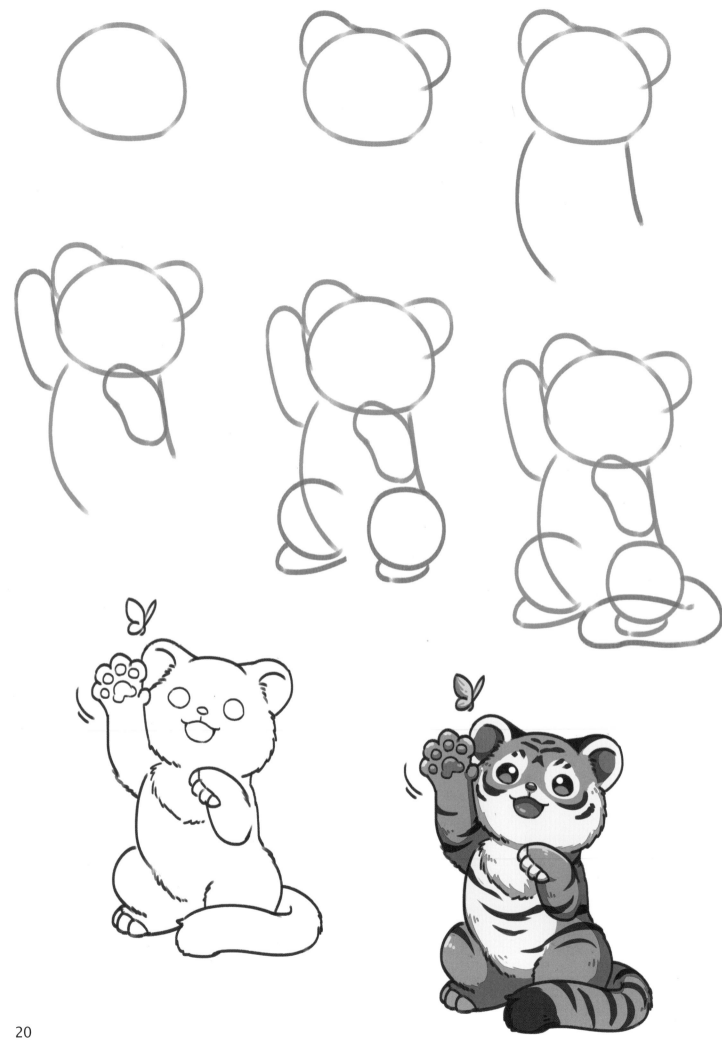

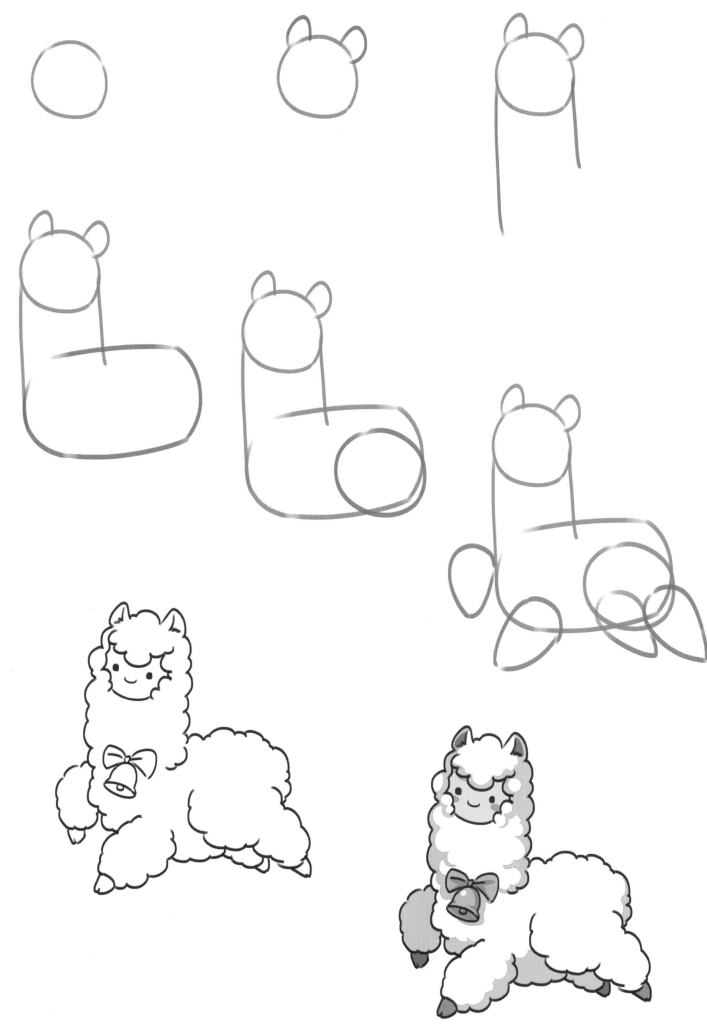

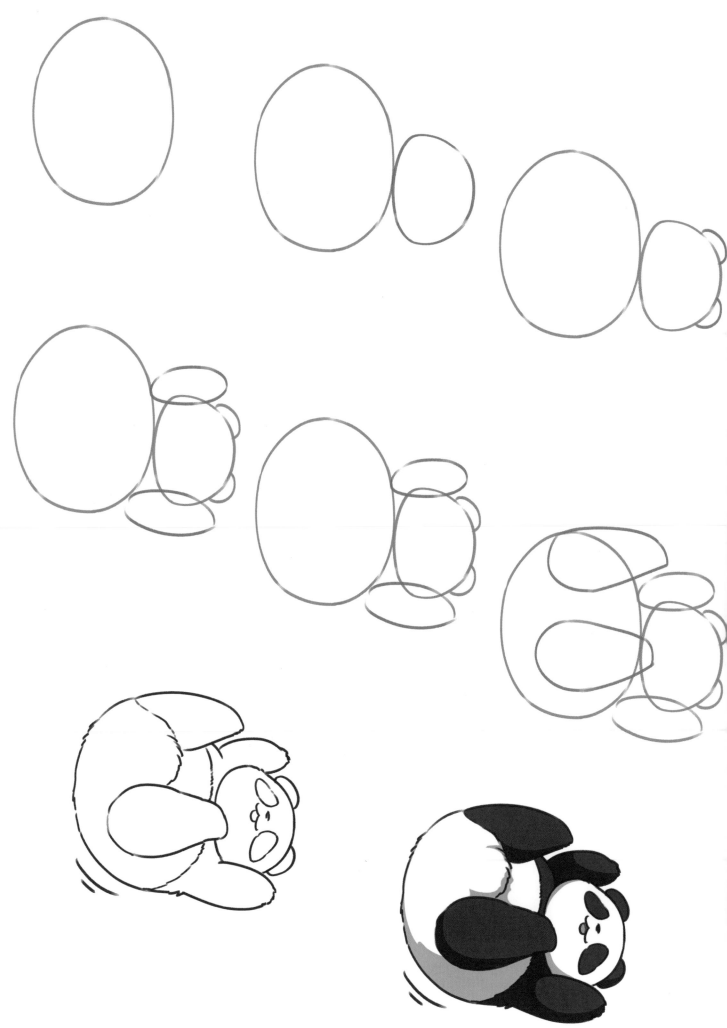

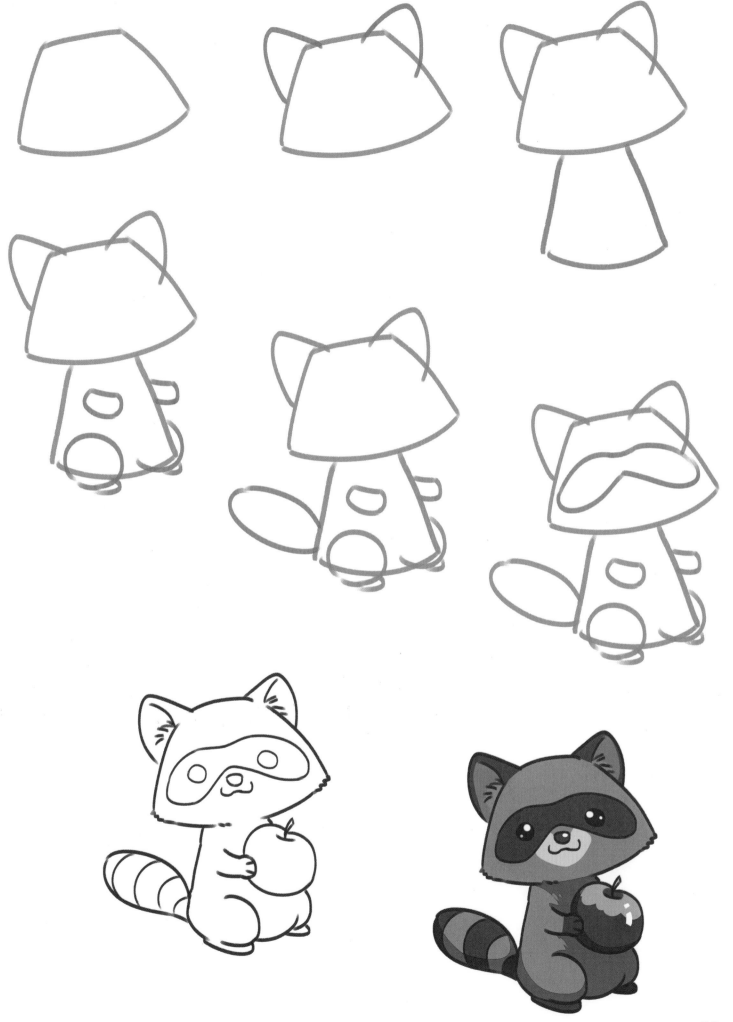

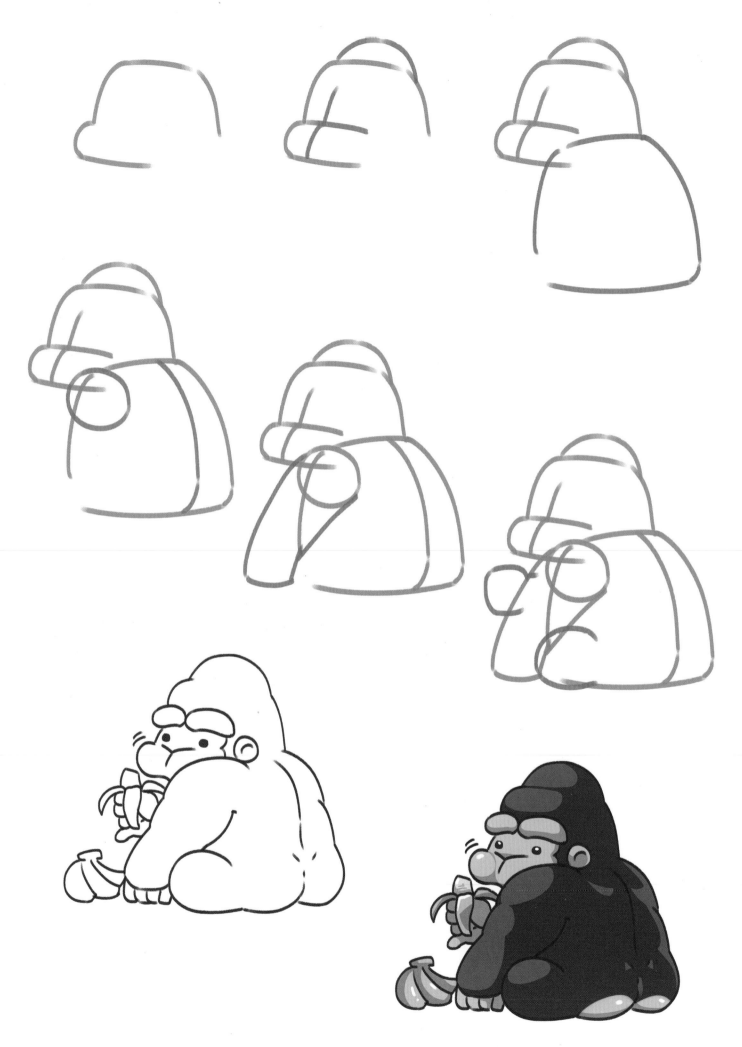

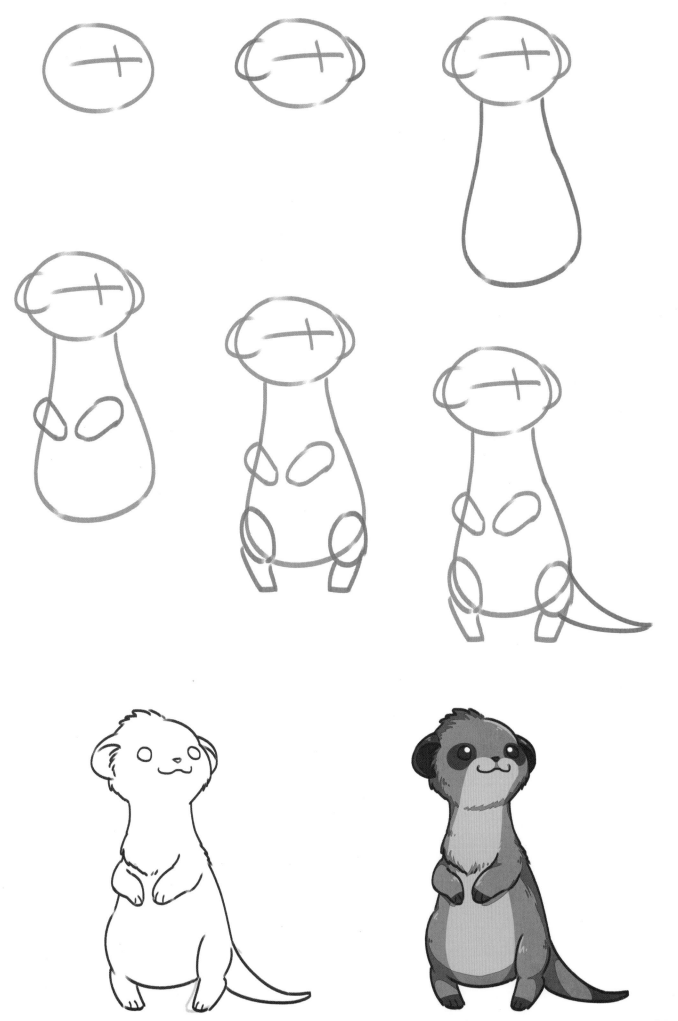

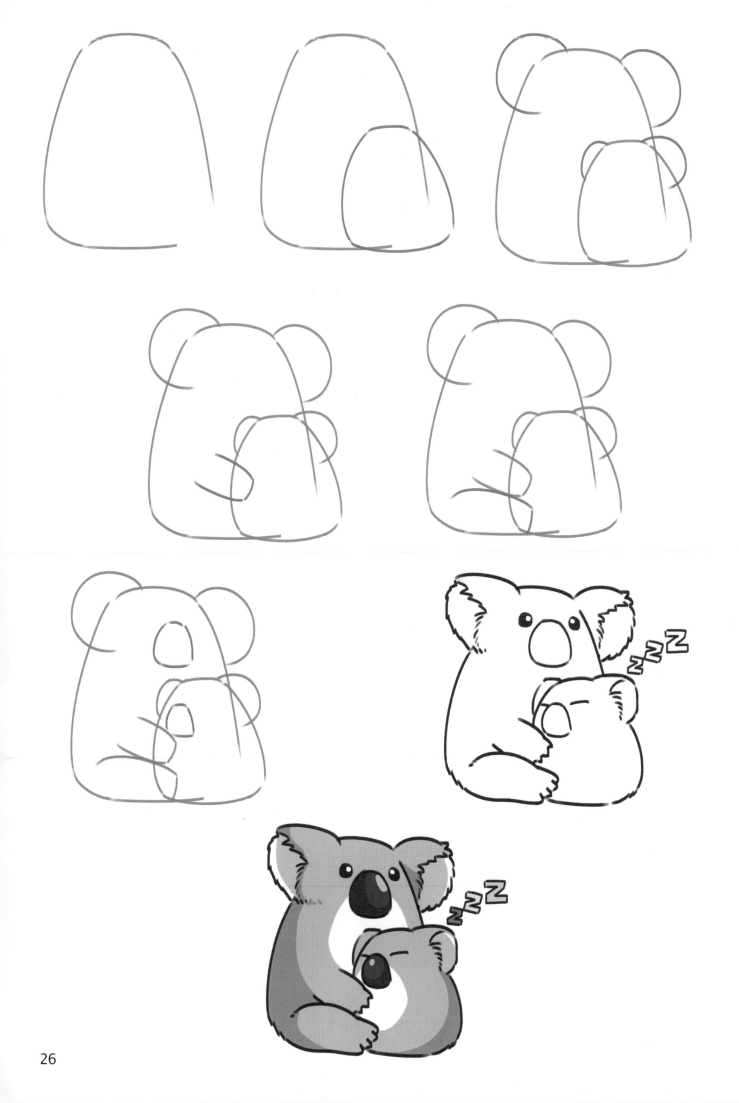

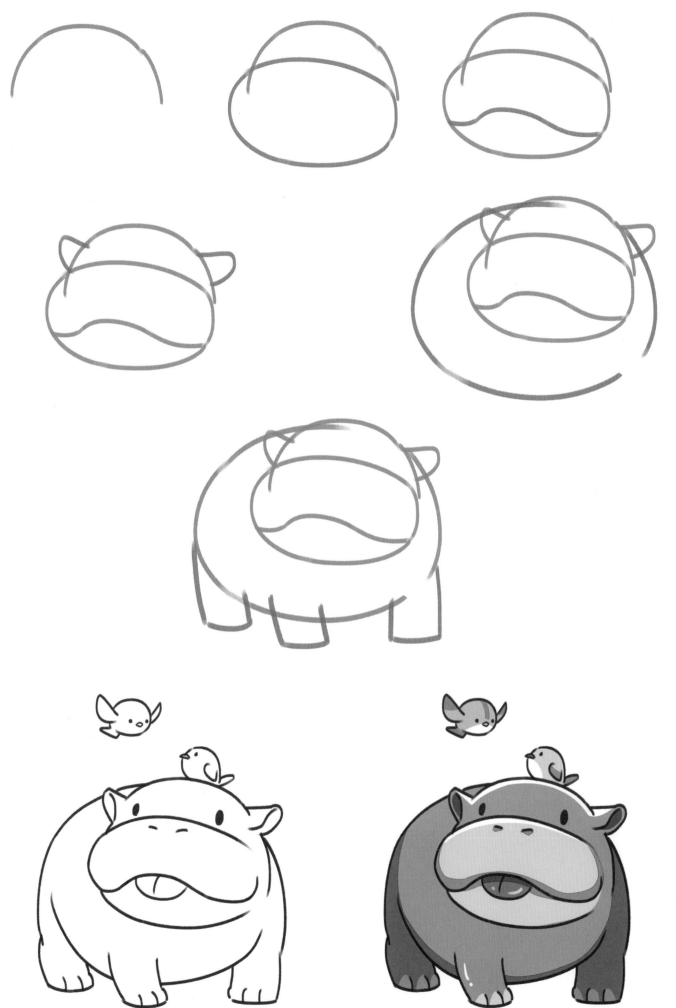

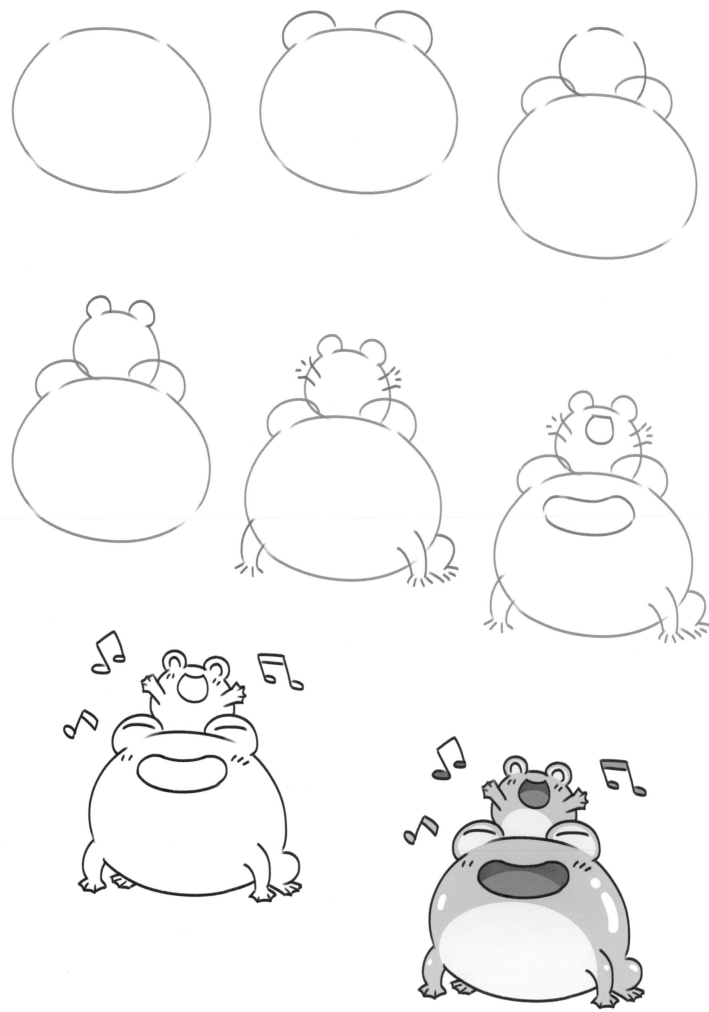

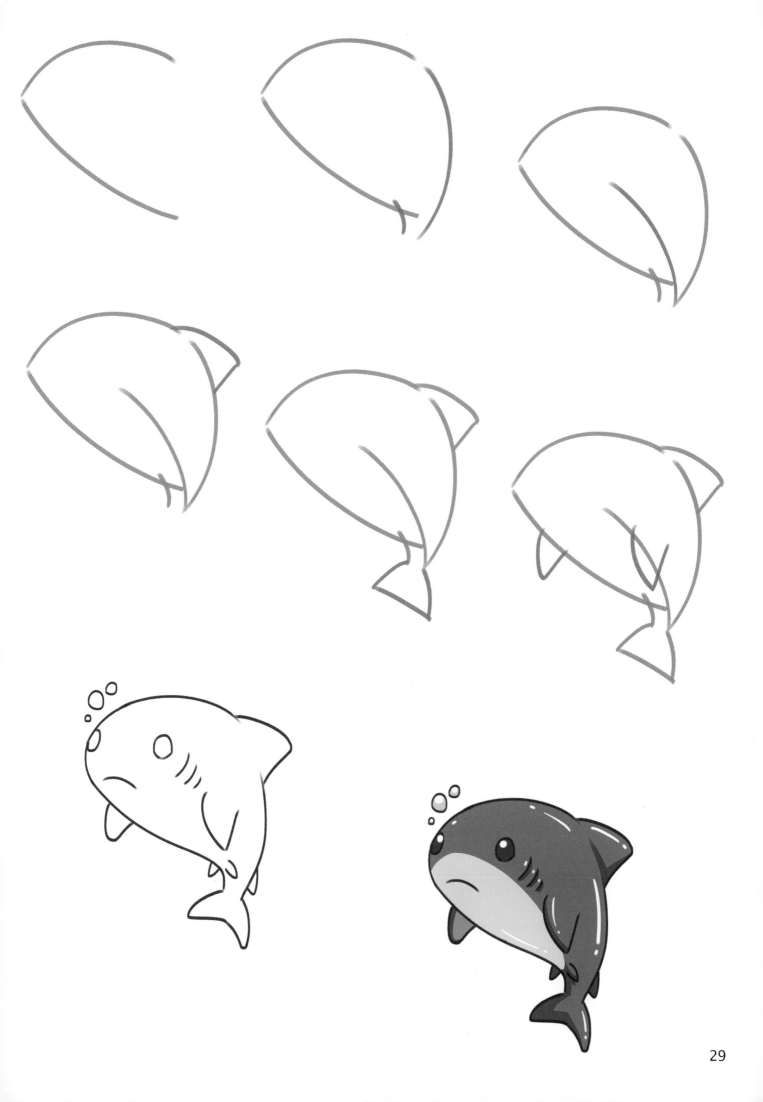

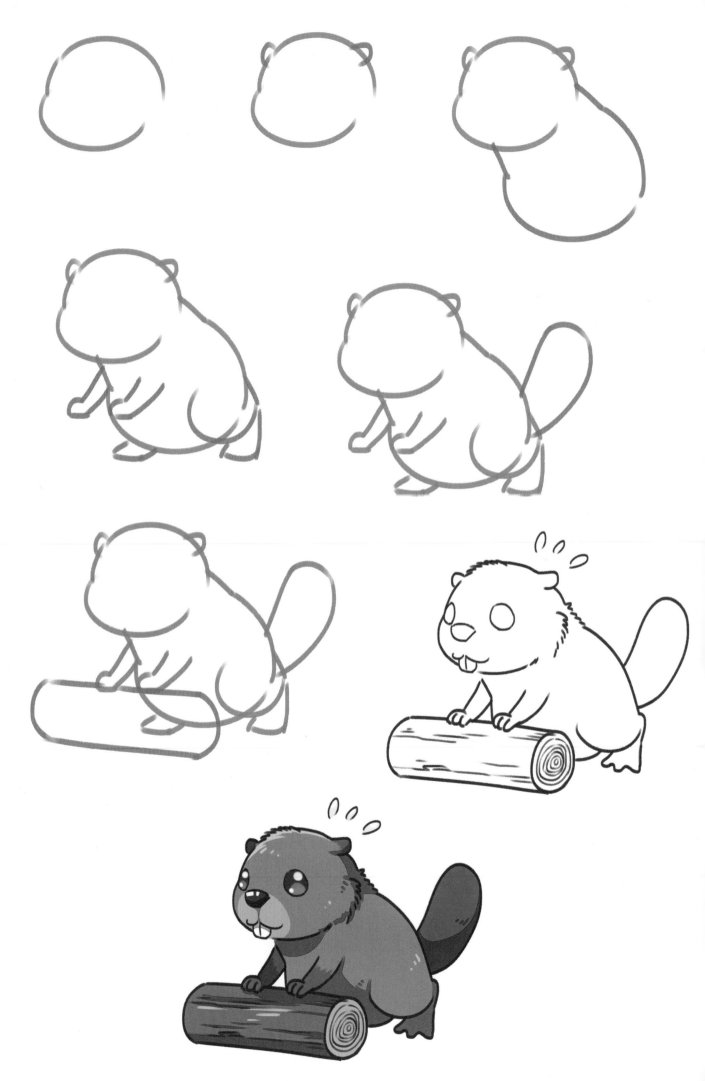

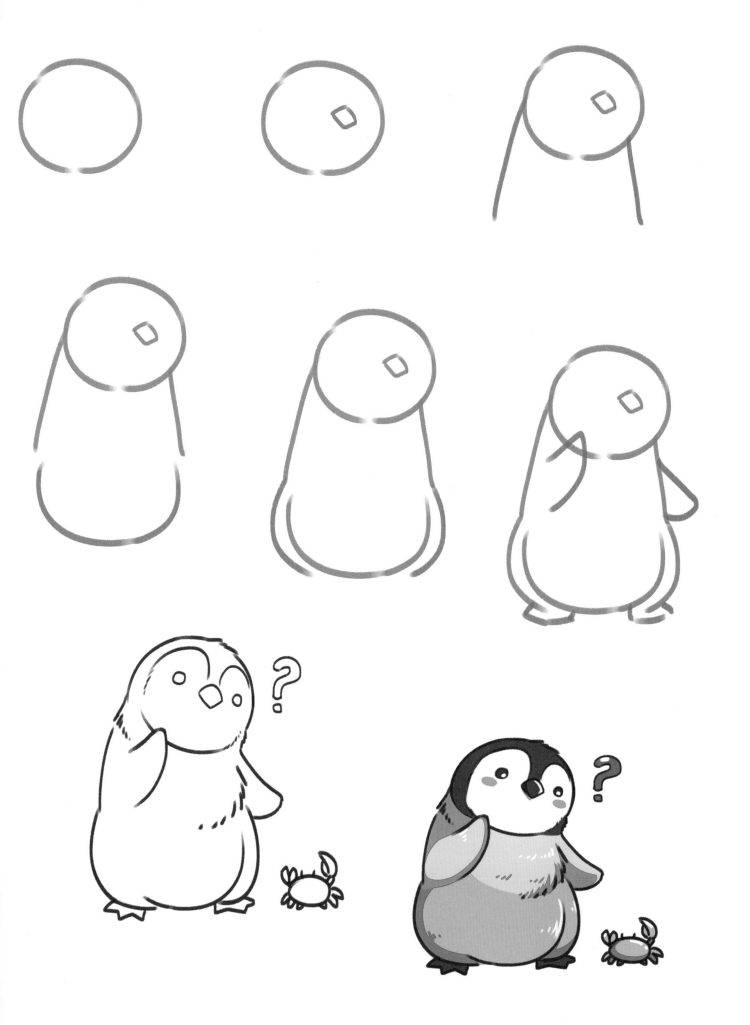

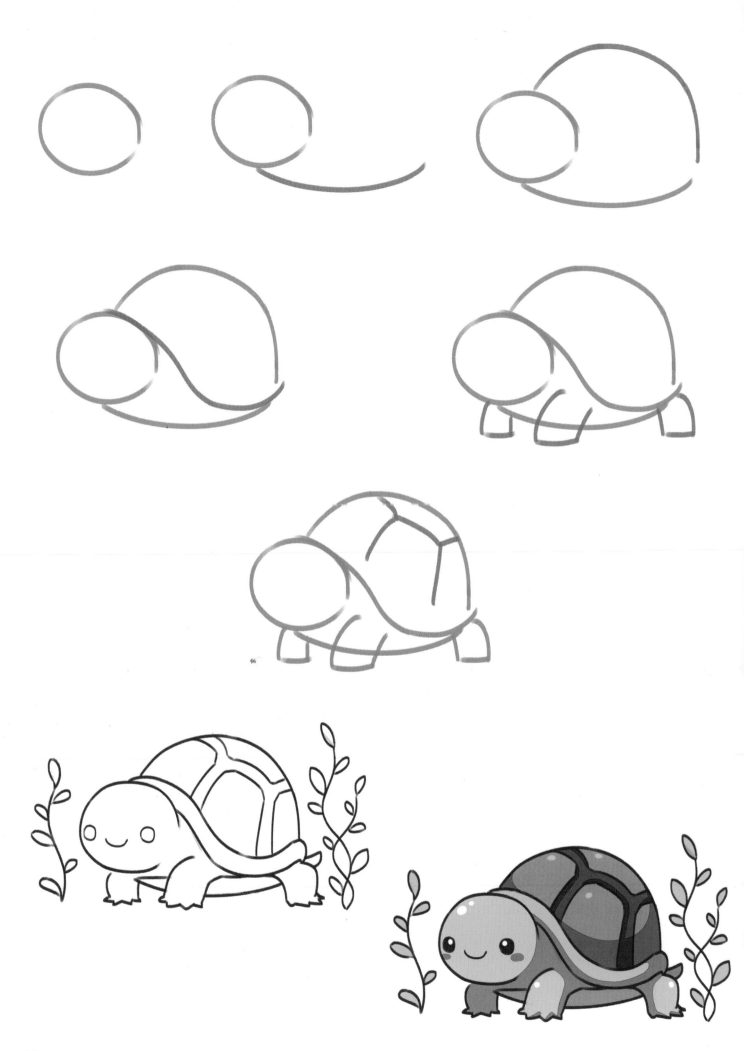